Southampton
SOLENT
University

MOUNTBATTEN LIBRARY

Tel: 023 8031 9249

Please return this book no later than the date stamped.
Loans may usually be renewed - in person, by phone,
or via the web OPAC. Failure to renew or return on time
may result in an accumulation of penalty points.

ONE WEEK LOAN

JOHN VIRTUE

JOHN VIRTUE

LONDON VENICE MONOTYPES

MARLBOROUGH

A PAINTER'S PROGRESS
JOHN VIRTUE'S MONOTYPES OF LONDON AND VENICE

by Paul Moorhouse

1 John Masefield, *The Wanderer*, in Selected Poems, selected by Donald E Stanford, Carcanet Press, Manchester, 1984, p82

Over the water came a lifted song –
Blind pieces in a mighty game we swing;
Life's battle is a conquest for the strong
The meaning shows in the defeated thing [1]

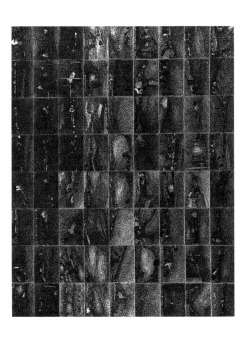

LANDSCAPE NO 7, 1978–81, black ink, pencil, charcoal and shellac on paper, laid on board, 190 × 239 cm. Private collection, London

THE MONOTYPES IN the present exhibition form a selection from a much larger body of work – more than three hundred and sixty prints – completed by John Virtue in several phases between October 2006 and September 2007. Taking London and Venice as their respective subjects, the prints represent a vision that, in numerical terms alone, impresses by the scope of its ambition. To survey the series as a whole is to witness the gradual but inexorable unfolding of extended variations on chosen themes. At the same time, each separate image appears as the unique product of that ambition, distilled and concentrated within particular marks and shapes. Individual inspection of the works reveals a sustained engagement with a restricted range of motifs in which the resulting images are distinguished by a remarkable diversity. Yet Virtue's treatment of two markedly different topographical subjects has a surprising unity. It is as if, collectively, the monotypes proceeded from some deeper, hidden, single source from which his work, in its entirety, derives. As such, while the monotypes mark a new departure for Virtue, they also extend preoccupations present from the outset.

Since 1978, when his first mature works were made, the central subject of Virtue's art has been the experience of landscape. Taking the places where he has lived and worked as his starting point, walking and drawing in situ have been fundamental, providing a

method and a way forward. From 1978 to 1988, his home was Green Haworth, an isolated and austere Lancashire village which he committed to paper in hundreds of small, intensely worked drawings in ink. From 1980, he arranged these images in large mosaic-like formations which he went on to overlay with passages of paint. In so doing, he breached the issue of scale. Close up these tessellated panels read in terms of concentrated detail. From a distance, the eye traverses the surface and registers its expressive energy. Since then, his activity comprises images that are large and physically imposing, and those that are tiny, yet no less resolved. It is a characteristic of Virtue's outlook, and one advanced powerfully by the monotypes, that his work is undifferentiated, in expressive terms, by issues of scale. The monotypes move seamlessly between expansive panoramas and diminutive evocations of space. But here, as ever, small images are never condensed versions of larger works. Whatever its physical dimensions, each work exists on its own terms as a complete, unqualified statement – indeed, as a defiant fact.

Between 1988 and 1997, Virtue lived in South Tawton in Devon. As would be the case in each of his moves to a new location, his way of working adapted with astonishing freedom to the demands exercised by the character of his surroundings. Overlaid with paint, the tessellated landscapes made in Green Howarth had moved

increasingly towards greater expressive breadth. In Devon, he extended this broader, more gestural approach. Using unstretched canvas laid directly on the ground, Virtue now made paintings in the landscape itself, responding directly to the observed subject. If previously his work had shattered the implications of scale, now he dissolved the distinction between drawing and painting, the unstretched canvas forming a sheet that received a spontaneously improvised drawing in paint. From this point, there is the compelling evidence of an absolute continuum between drawing and painting. This ethos has directed the course of his art, and it feeds directly into the monotypes where the relationship between these two modes of expression achieves an ideal synthesis.

The method that defines Virtue's present, distinctive way of working originated ten years ago. In 1997, he moved again, this time to Exeter. For the next five years he made the Exe estuary his subject, and in his response to that motif a characteristic pattern or ritual emerged. At the same time on the same day every week, Virtue commenced an eleven-mile walk down the estuary. During the course of his journey he paused at the same spots and made rapid sketches in the eight fresh sketchbooks he carried with him. All the time his walk proceeded towards a distant destination: the tower of All Saints Church, just visible on the horizon. By the end of the day, he would

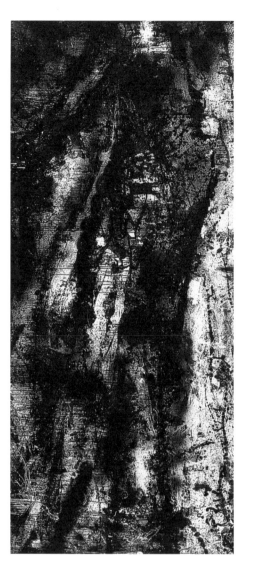

LANDSCAPE NO 148, 1986, black ink, shellac, acrylic and emulsion on canvas, 230 × 480 cm. Collection David Bowie

have filled each of the books with drawings, some four hundred images in all. Back in the studio, these quickly executed sketches formed an ever-growing library of visual references; thousands of drawings, a diary of observation and endurance, which fed the formation of paintings. In the isolation of his workplace Virtue used the drawings to re-enact and re-invent his earlier experiences in the landscape, exploring his imaginative engagement with an external subject in the form of paintings executed in acrylic, ink and shellac on stretched canvas. Once again there was the evidence of a will to dissolve boundaries. Virtue's sensibility now increasingly straddled direct observation and imaginative invention. This characteristic, too, is central to the way the monotypes were made, demonstrating that Virtue's work continues to sustain a tension between these opposing forces.

Virtue's paintings of the Exe valley have an ostensible rural subject, and these works marked the emergence of sky and water as dominant elements in his imagery. Typically, the landscape is suspended between a vast looming space filled with movement and, below that, its reflected presence in the form of fugitive shapes on a shifting surface. At the centre of this visual drama the church tower forms a focal point, nailing an image that seems on the verge of disintegration. This device – a still centre amidst chaotic forces –

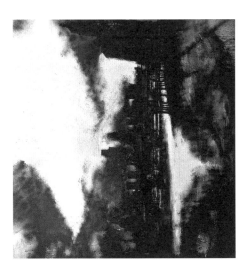

LANDSCAPE NO 709, 2003–4, acrylic, black ink and shellac on canvas, 350 × 366 cm. Private collection, New York

endures to the present. In the monotypes of London and Venice, the domes of St Paul's and Santa Maria Della Salute have a similar presence and function, traceable to earlier appearances of a church tower in the Exe paintings and, before that, in the Green Howarth drawings.

When Virtue left Exeter for London in 2002 he exchanged a rural subject for one rooted in the architecture and energy of the metropolis. As associate artist at the National Gallery, Virtue occupied a large studio beneath the historic building on the edge of Trafalgar Square. Latterly his workplace was a confined arched space beneath Waterloo Bridge, near the Courtauld Institute. Over the next five years London became Virtue's sole subject and, as with his earlier relationships with his surroundings, something of an obsession. Working in close proximity to the Thames, his daily routine involved walking to the jetty on the river's south bank, or sometimes descending onto the mud below. From these positions he made innumerable drawings of the view looking towards Blackfriars Bridge and the City. Back in the studio, these intensely wrought fragments were the source material for paintings, forming an ever-growing lexicon of shapes and marks from which the original experience of standing by the river's edge could be explored afresh. The London paintings are a world away from their predecessors which were set in nature.

A new formal language emerged, one dominated by architectural shapes. Domes, bridges and jetties formed a new skyline, unmistakably man-made. Yet the sky and the land, light and water, air and reflection are common to both Virtue's rural and urban subjects and provide an essential link between them. Indeed it is apparent that for Virtue the relationship of these elements has a deeper, ontological significance that transcends locale. In the paintings both of the Exe estuary and of London, and now in the monotypes of London and Venice, the skyline is an *idée fix* : a vital track of visceral energy coursing through an uncertain space.

The original idea for Virtue's monotypes came in the form of an invitation from Marlborough Gallery, made in August 2006, that he participate in a scheme run in cooperation with the International School of Graphics in Venice. Now in its sixth year, the scheme provides artists with the opportunity of spending three weeks in Venice making prints. Virtue viewed this prospect with some trepidation. His way of working presumes a close, prolonged visual involvement with his immediate surroundings, so that he is, in a sense, steeped in his subject. Venice would be a new motif and, as his time there would be limited, the proposed project would entail his articulating an almost immediate response compressed into a relatively short period. His usual process involved extended

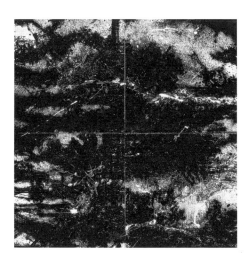

LANDSCAPE NO 624, 1999–2000, acrylic, shellac and black ink on canvas, 366 × 366 cm. Tate, London

familiarisation with his surroundings, walking, looking, drawing and – during painting – the prolonged reworking of particular images. It appeared that all this would be completely negated.

He also foresaw a further, fundamental difficulty. Virtue was completely unused to the process of making monotypes. Indeed, with the exception of some earlier etchings, printing was an entirely unfamiliar medium, all his work having been concentrated on painting. As a way of making images, printmaking seemed alarmingly unsympathetic and unsuited to an ethos rooted in isolation and founded on the directness of drawing on paper and painting on canvas. Making prints would involve skilled intermediaries. There would also be an inevitable hiatus between the formation of an image on a printing plate and its transfer to the sheet of paper receiving that image. As a result, he had no confidence whatever that, working in this way, he could make prints at all. Despite these misgivings Virtue decided to try.

In October 2006, he was introduced to the printers Mike Taylor and Simon Marsh, both of Pauper's Press. For the last five years, Taylor and Marsh had been running the Venice summer workshops, working with other invited artists, and they were to be involved with producing the prints. In order to familiarise himself with the mono-type technique Virtue began by making images of the Thames

subject on metal printing plates, working from his usual vantage point on the river's south bank. In this way, he addressed a motif with which he was already closely involved and preparing the prints in front of the motif would, he felt, be no different from his regular drawing ritual. This opening gambit was something of a disaster. Virtue hated working on the spot encumbered with printing plates and found he was unable to proceed in this way. The breakthrough came when he realised that he could simply adapt his existing practice. Reverting to making drawings on paper in the landscape, he then used these studies as the basis for the prints, the plates for which were prepared at Pauper's Press. When he came to create the monotypes in the studio, he found that he could work in ways that closely resembled his painting technique. Using the drawings for reference, the images he improvised on the printing plates came quickly, brushes, rags and sprays being employed to keep the motif in movement. As before, another boundary had been dissolved as drawing, painting and printing were now brought into alignment. Central to Virtue's monotypes is that effectively they are paintings on paper and, as such, they are a continuation of his work as a painter.

Between October 2006 and March 2007 Virtue translated the Thames subject into monotype, a medium that became increasingly

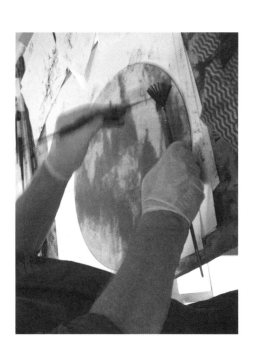

In terms of their facture, the London monotypes represent the seamless transition of an existing and ongoing subject from the medium of paint to that of monotype. There is the familiar evidence of rapidly brushed marks, spraying, wiping back and the progressive re-working of the image. That said, the monotypes are not simply analogues for the paintings. They also significantly extended Virtue's way of working. Whereas the surfaces of the paintings frequently attest a process of protracted change, the prints retain a feeling of spontaneity. Japanese brush painting is a long-standing model for Virtue's practice and is a digested element of his approach to mark-making in his paintings. The fluidity of the print medium meant that the monotypes could be made with greater speed and the image could be wiped. Entire passages could be wiped way and supplanted with swiftly made marks. No less substantial than the paintings in terms of their content, the London monotypes nevertheless move towards a more abbreviated form of expression.

Making the monotypes in London formed a vital preparation for Virtue's impending work in Venice. His initiation stretched over six months and came to a halt in March 2007. A gap of over four months ensued, during which he continued to paint and, coincidentally, oversaw the final stages of a long-contemplated move to Italy. During this time some of the lessons he had learnt from

attuned to his needs. By the end of this period, he had made 129 prints, in various sizes. This is a prodigious output, given his previous unfamiliarity with this way of working. One of the most remarkable characteristics of these prints – in addition to their closeness to his paintings of this subject – is the sustained intensity common to both ways of working. It is clear that from the outset Virtue was determined to make no concessions to the change of medium or method. As in the works on canvas, the monotypes are dominated by the ever-present dome of St Paul's cathedral. Virtue's extended treatment of this motif wrests it from simple connotations of architecture. While it forms a recognisable point of reference and anchors the expressive energy within each image, Virtue's response transcends the topographical. Wren's masterpiece undergoes a relentless process of interrogation and transformation. In *London No 127*, its bulbous profile is seen from afar, part of a longer, sinuous skyline. In *London No 47* it is ascendant, drawing the eye to the centre of the image. At times it is a brooding shape, black and ominous. In *London No 26*, it is an ethereal presence, suffused with light, on the point of disappearing. Virtue's response is that of one protagonist to another. His depiction of St Paul's invests the motif with qualities of changing character and mood: human qualities that impart a sense of life.

making monotypes began to filter through to the paintings on which he was then engaged, so that the two ways of working cross-fertilised. Following this break with printing, he then took up his pre-arranged appointment and arrived in Venice on 13 August 2007. He immediately confronted a startling new subject: a place he had visited only once previously, yet one he felt he knew through his long-standing acquaintance with Turner's great watercolours of a city dissolved by light. Venice's miraculous marriage of architecture, sky and reflection presented a view at once entirely alien yet also immediately familiar, even ingrained. Yet, as he had anticipated, the prospect of engaging with a subject so steeped in history and, it has to be said, so patinated by the accretion of cliché, was utterly intimidating.

The Venice monotypes can be seen as the outcome of a remarkable concentration of Virtue's usual practice. His first imperative was to seek out the motifs on which he would focus. Among the options he considered were the bridge at the Rialto and the square at San Marco. Neither gelled as subjects and he rejected both. Using waterbuses to get around the city, his attention then focused on the lagoon itself and finally two subjects seemed to strike a chord. The motifs that form the basis for Virtue's entire output are of those of the domed basilica of Santa Maria Della Salute, and the island of San Giorgio Maggiore.

Virtue's time in Venice fell into two phases: the first week was spent drawing in situ, the final fortnight was taken up by an intensely focused, and ultimately exhausting, round the clock confinement in the printmaking studio. Notwithstanding his earlier involvement with the London monotypes, he began in a state of complete uncertainty. Virtue was concerned by the way that the transfer of the impression during printing would inevitably reverse the image. He experimented by making the initial drawings on tracing paper, thinking that the sheet could be simply turned over to provide a reversed visual reference when working on the printing plate. This approach proved too cumbersome and was abandoned, as if realising that the images he would make had to be liberated from literal description. An extraordinary aspect of the Venice monotypes is that while the images *do* reverse the appearance of the subject this is virtually imperceptible, so completely are they imbued with the essence of the place.

The will to penetrate the character of a motif and then withdraw, standing at an abstracted remove from the source and reinventing it under the pressure of subjective forces, is central to Virtue's work. This imperative dominates the Venice monotypes. For this reason, it is not surprising that during the initial, experimental phase Virtue resisted the suggestion that the monotypes employ colour. Since

1978, his art has been restricted to black, white and a spectrum of intermediate greys. His use of monochrome is in some ways one of his work's most conspicuous characteristics and has an almost ethical force. There is a sense he believes that colour would qualify or embellish the material fact – and clarity – of his vision. In Venice, the formation of the images proceeded from observation and its opposite: invention. This dichotomy demonstrates his awareness that we do not see the world directly, but apprehend it through the lens of experience, through the subjective structures we impose upon external reality. The expressive, gestural force of Virtue's imagery is a powerful vehicle for that vision. His images evince a struggle to make visible what he describes as 'actuality'; a view of the world in which the objective and the subjective are held in balance. Colour would add to the difficulty of stating that actuality as directly as possible. With notable exceptions the monotypes he went on to make are, like his paintings, rooted in a monochrome language of form and feeling.

Having set his compass with these decisions, the monotypes represent the growing freedom he felt to manipulate time, space, architecture, light and water. It is perhaps a paradox that the Venice images, in common with his wider practice, entailed this close involvement with place and, at the same time, they reflect an impulse wilfully to disrupt topography, history and description. By these means, Virtue engaged with subjects endlessly reproduced both on the pages of art history books and as postcards for the tourist trade. And yet, against these odds, he succeeds in refracting these familiar motifs in unexpected ways, so that they resonate with new connotations of feeling and meaning.

Working in the studio during the final two weeks, Virtue called upon the drawings he had made: a huge repository of visual information. These studies traversed the motifs by presenting them from multiple different views. As he improvised around this material in new images made on the printing plates, the two motifs yielded an astonishing richness of variation, complex development and recapitulation. Progressively, the source material was extended and transformed, each print adding continuously to an expanding diversity of treatment in terms of handling, scale, format and mark-making. The pattern that emerged was one of increasing freedom, economy and invention. Prints completed earlier in the proceedings, notably *Venice No 2, No 4* and *No 17* are close to the initial subject. They are remarkable evocations of light and reflection, atmosphere and space. From the start, Virtue embraced a variety of shapes, as well as different scales, so many images are presented as tondos or ovals. These formats occasionally invest the images with the

character of a view seen through the lens of a camera obscura – at once immediate, yet removed from direct visual contact. The abstractedness of the images deepened as Virtue gained increasing confidence, and in prints such as *Venice No 79*, *No 78* and *No 102* there is an expressive vitality that subsumes description. By the end of series, in works such as *Venice No 291* the distant island of San Giorgio Maggiori has an ambiguous, spectral quality. In *Venice No 271*, Della Salute is adumbrated by an urgent flurry of brushstrokes. Individually and collectively the prints impart a unique experience: the sight of Venice caught up in its own mystery, enveloped by the means of its representation.

By 31 August, the date which signaled the end of the project, Virtue had completed over three hundred prints, of which sixty were destroyed as part of an ongoing editing process. The implications of this astonishing achievement can be sensed: over a two week period, his output had continued without abatement and, in fact, only finally ended when the stock of paper was exhausted. On his return to London, there was a remarkable coda when in mid-September he completed a further four large scale Venice prints: magisterial images in which the entire experience received a complex and fully developed summation. Shortly afterwards, Virtue closed down his painting studio and left London to live in Italy. In so

doing, he vacated the city that had provided his subject for the previous five years to continue his work in a new location. In telling ways, the London and Venice monotypes stand at this important juncture in Virtue's art. They draw together themes that have governed the progress of his work for almost thirty years, and they point the way to its future development.

LONDON

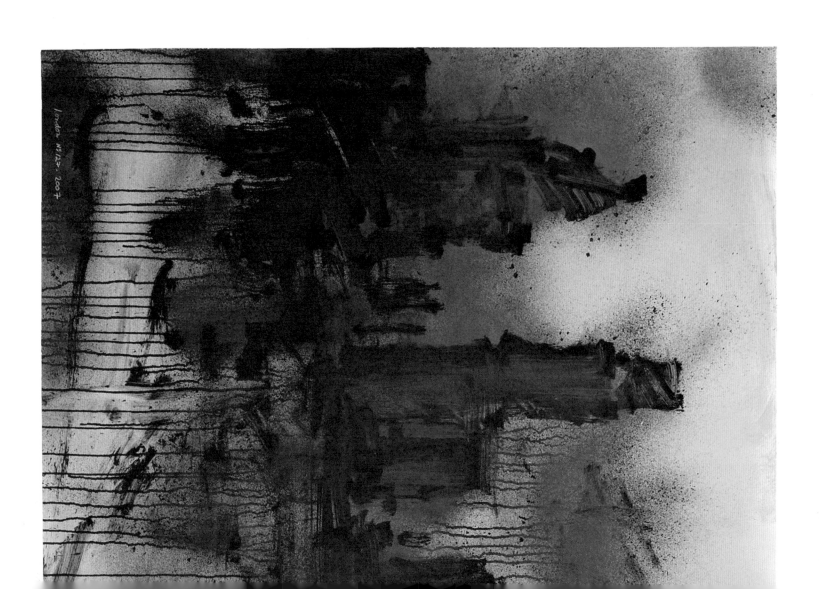

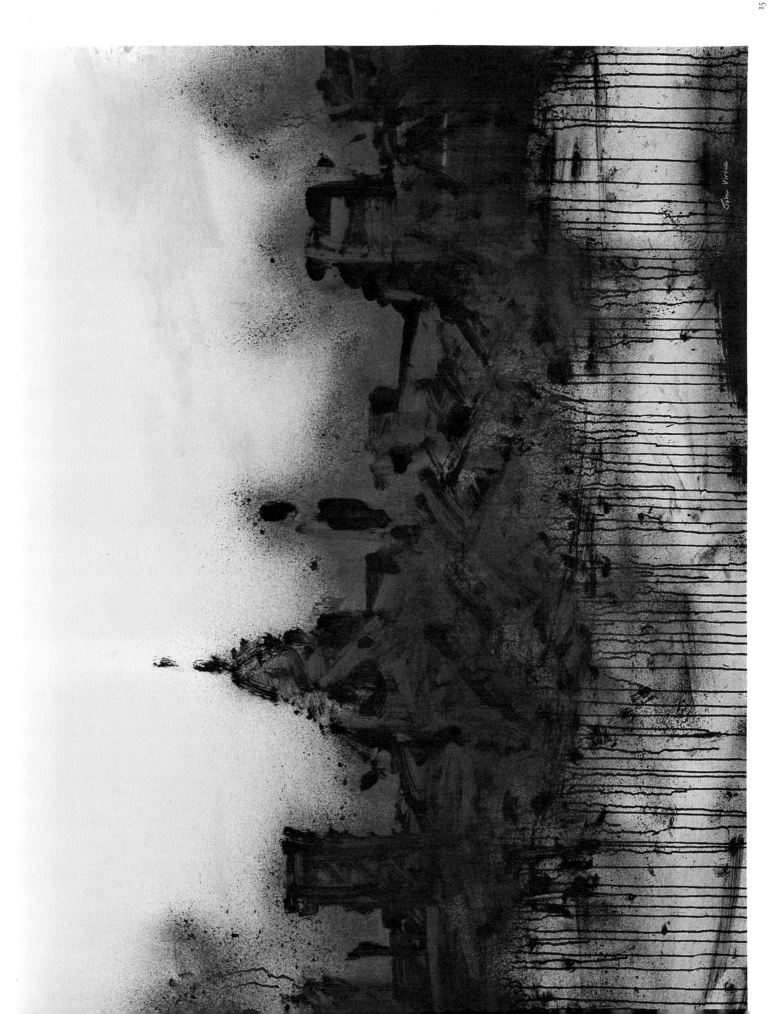

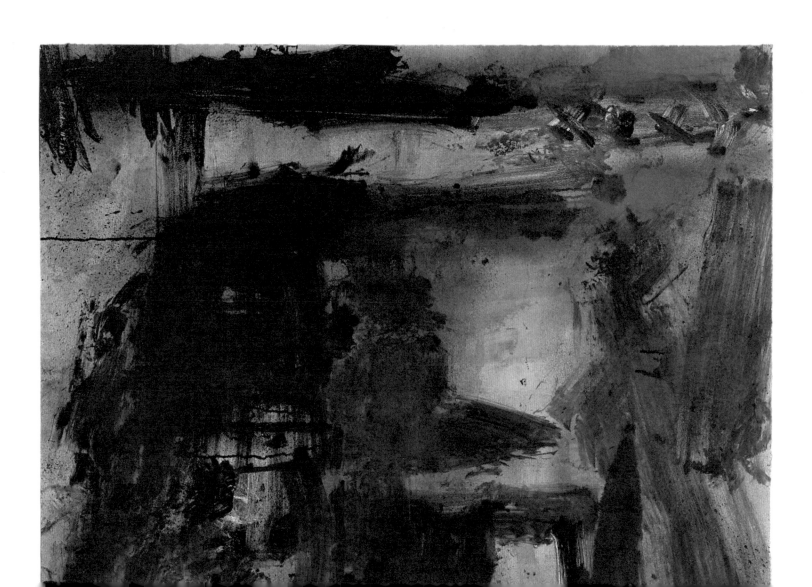

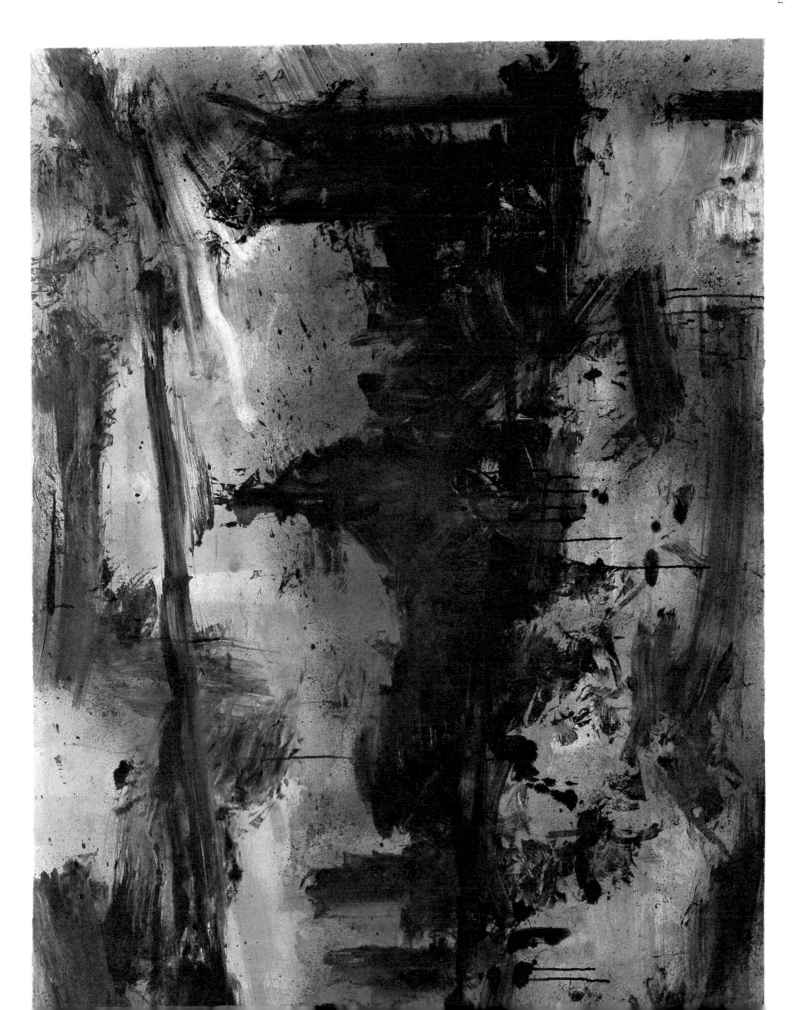

LONDON NO 9

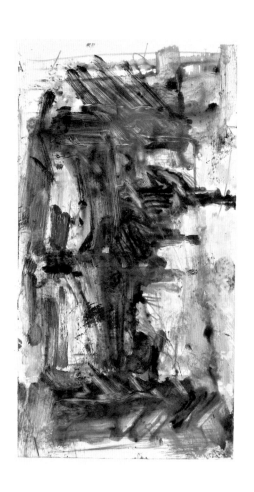

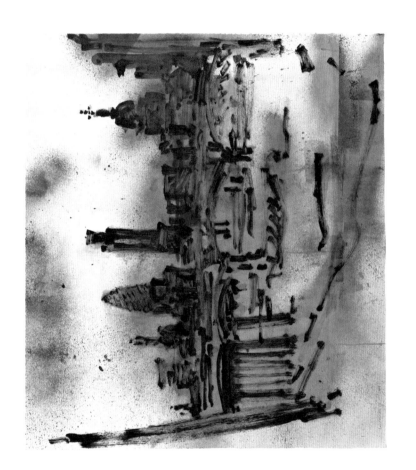

LONDON NO 14

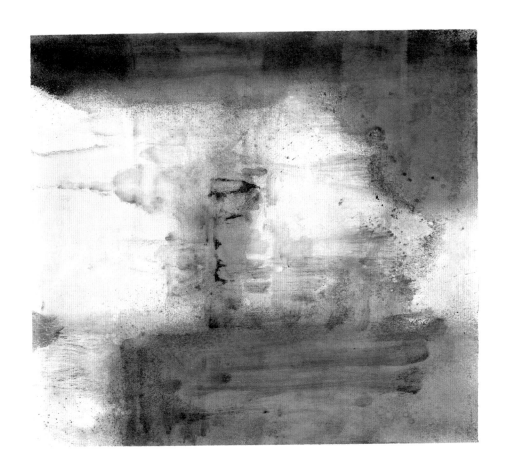

LONDON NO 26

LONDON NO 29

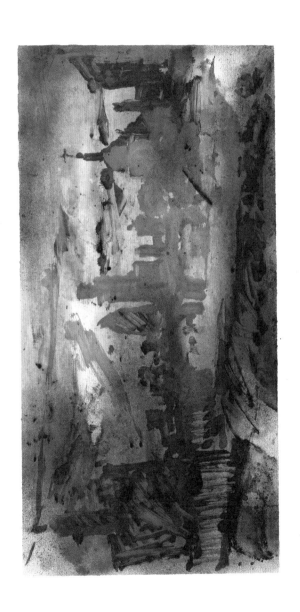

LONDON NO 34

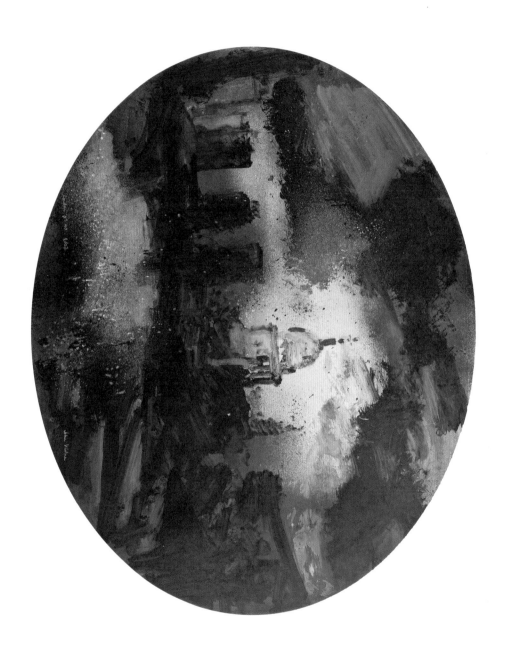

LONDON NO 40

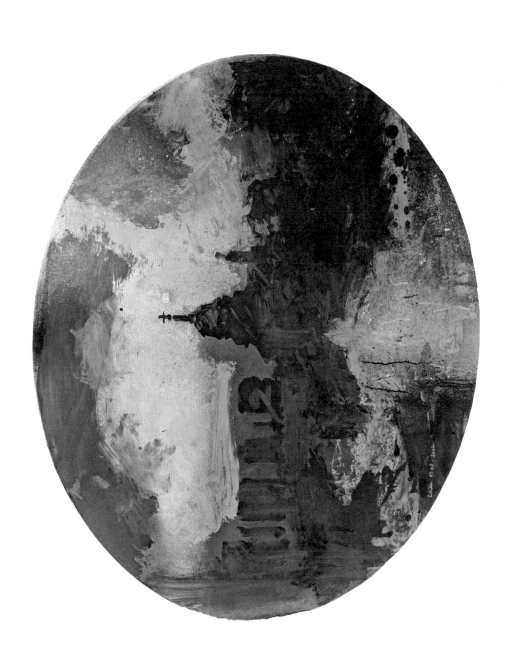

LONDON NO 43

LONDON NO 47

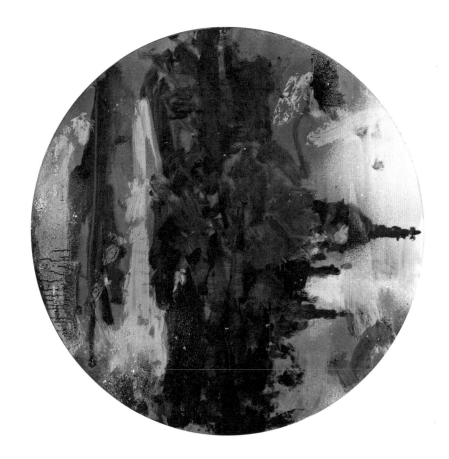

LONDON NO 50

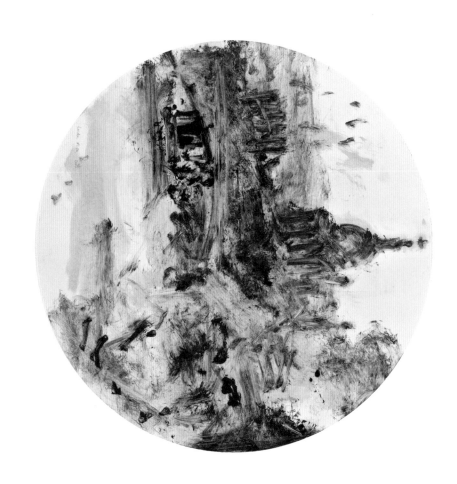

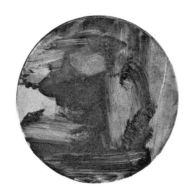

LONDON NO 59

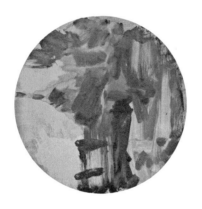

LONDON NO 58

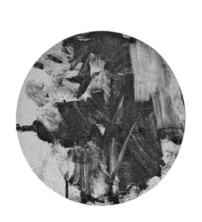

LONDON NO 57

LONDON NO 61

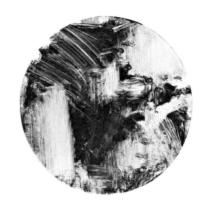

LONDON NO 66

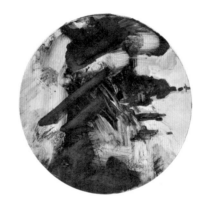

LONDON NO 67

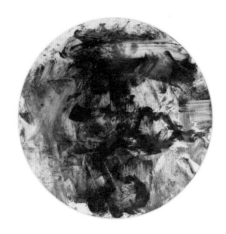

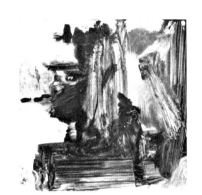

LONDON NO 79

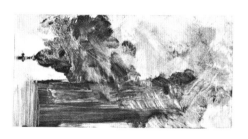

LONDON NO 76

LONDON NO 83

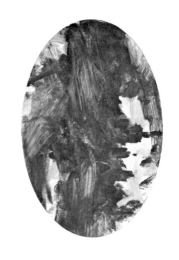

LONDON NO 92

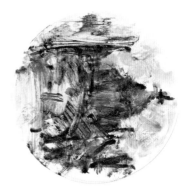

LONDON NO 93

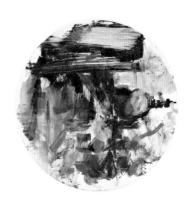

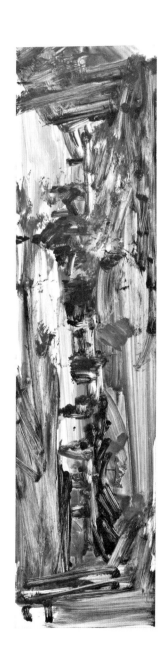

LONDON NO 97

LONDON NO 109

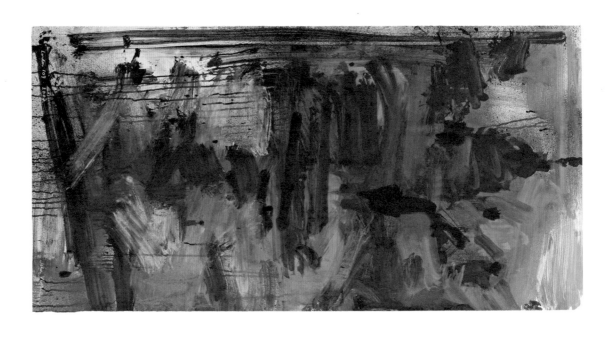

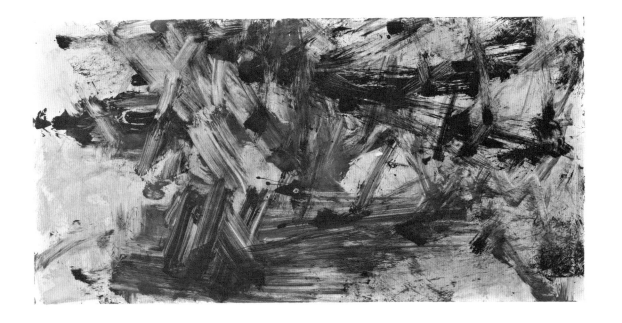

LONDON NO III

VENICE

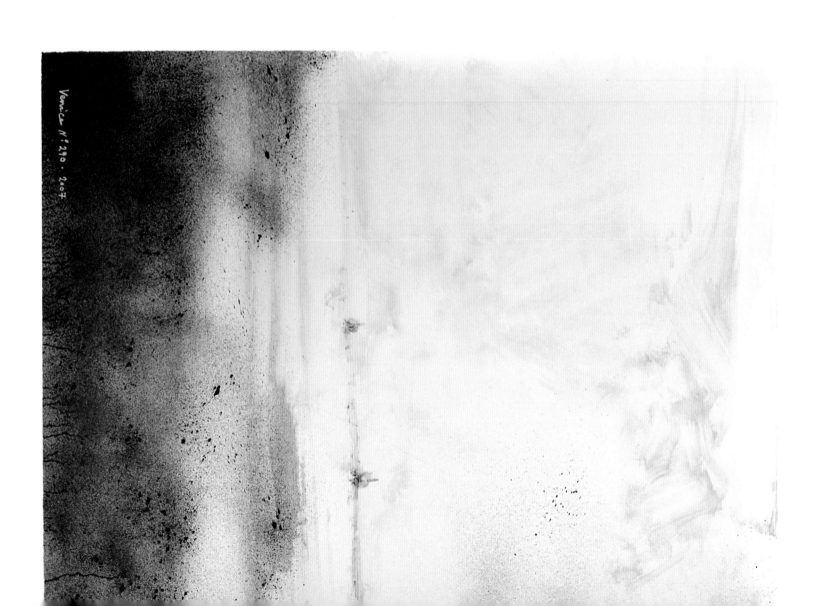

Venice N° 290 · 2007

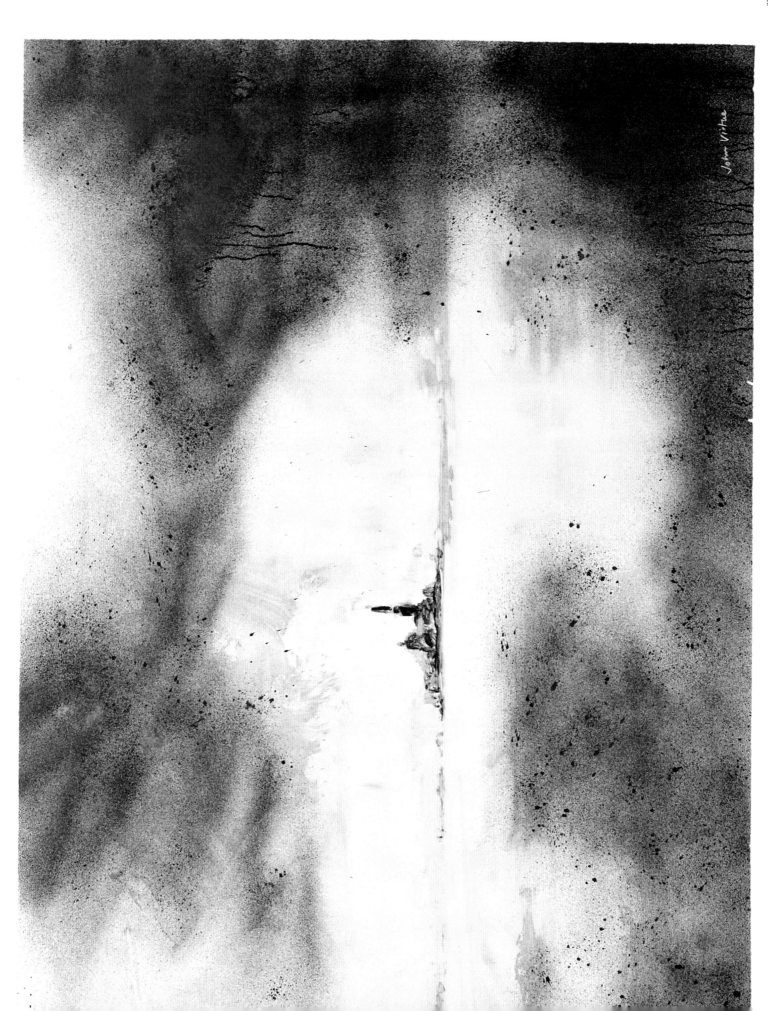

John Virtue

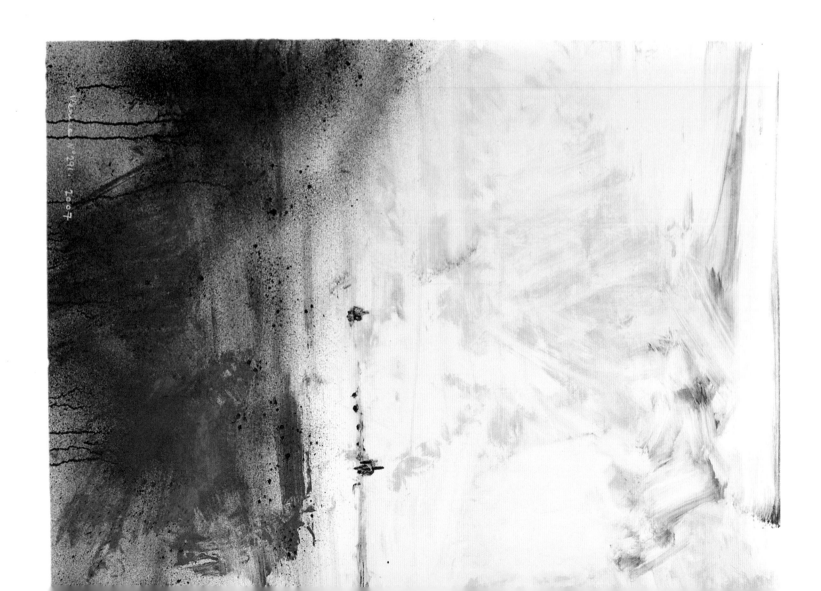

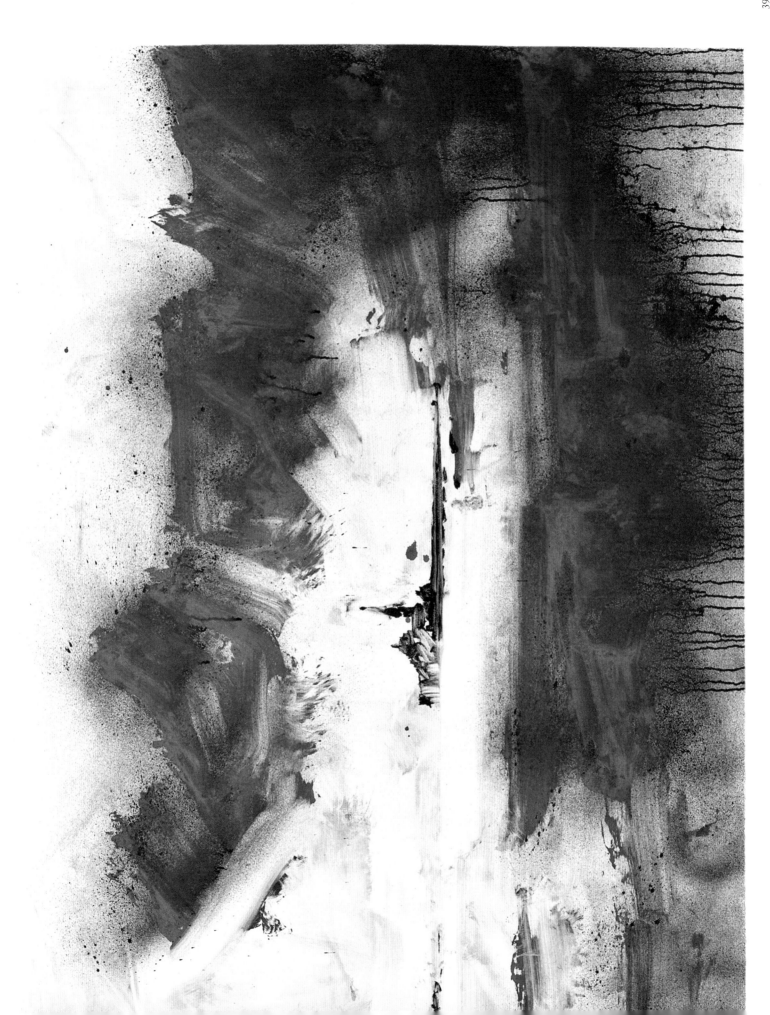

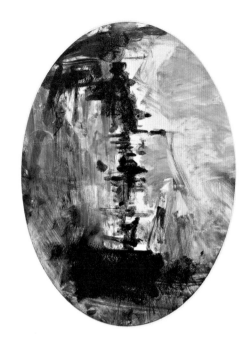

VENICE NO 2

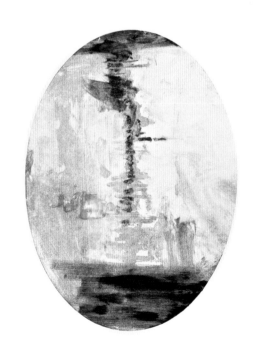

VENICE NO 4

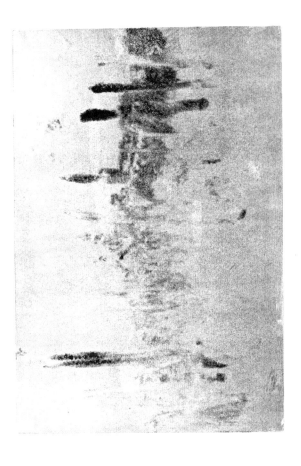

VENICE NO 24

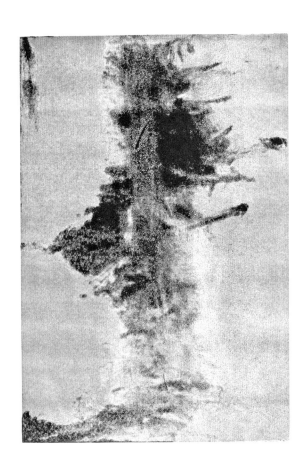

VENICE NO 17

VENICE NO 25

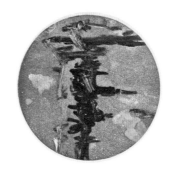

VENICE NO 31

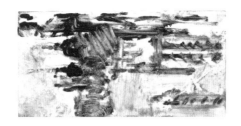

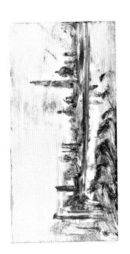

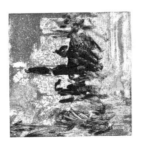

VENICE NO 38

VENICE NO 33

VENICE NO 32

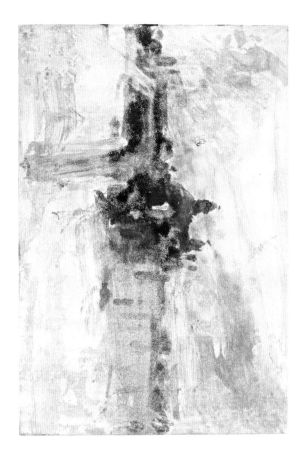

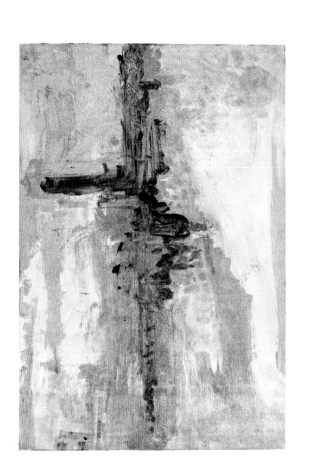

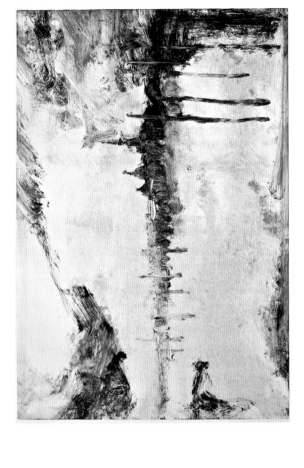

VENICE NO 75

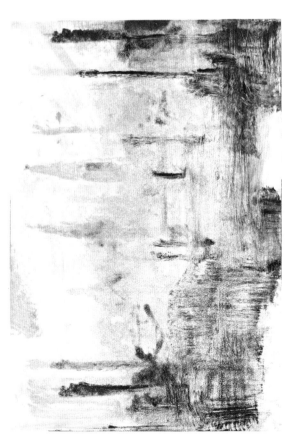

VENICE NO 70

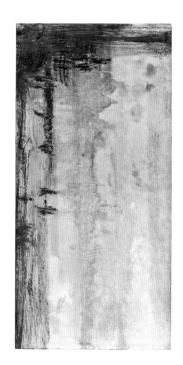

VENICE NO 77

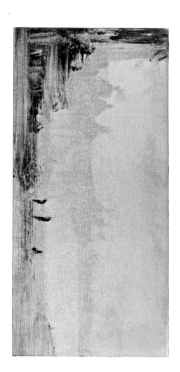

VENICE NO 78

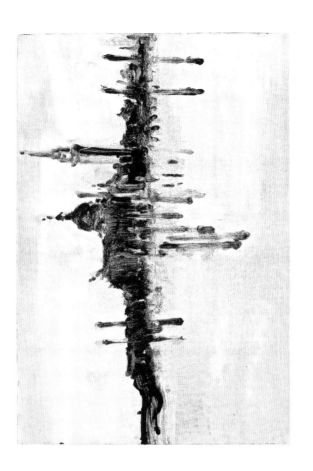

VENICE NO 85

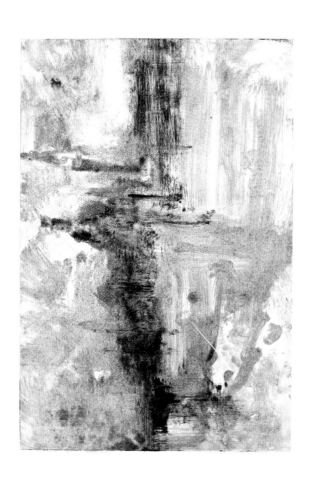

VENICE NO 82

VENICE NO 87

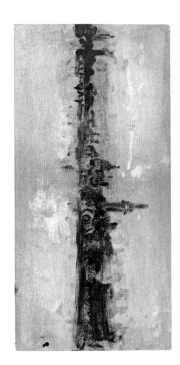

VENICE NO 90

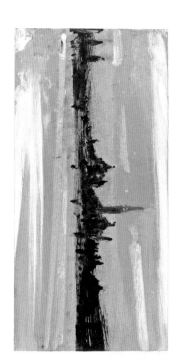

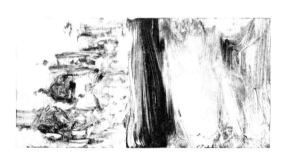

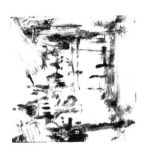

VENICE NO 103

VENICE NO 102

VENICE NO 99

VENICE NO 109

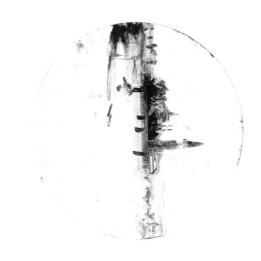

VENICE NO 114

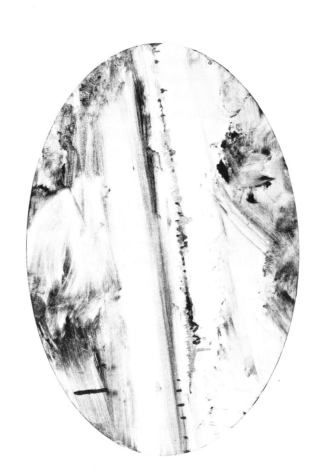

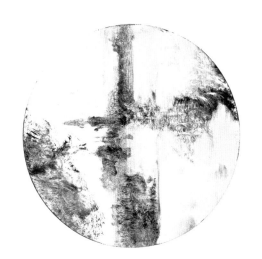

VENICE NO 125

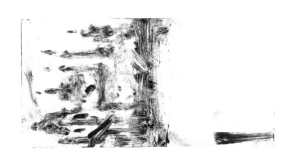

VENICE NO 119

VENICE NO 129

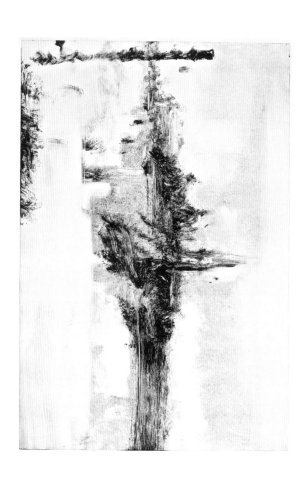

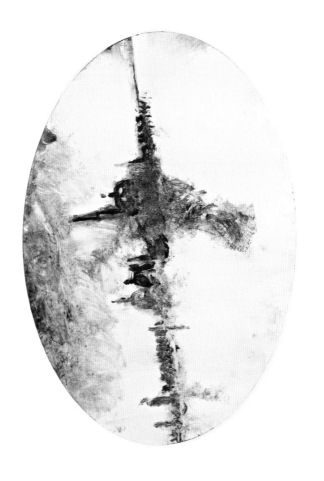

VENICE NO 143

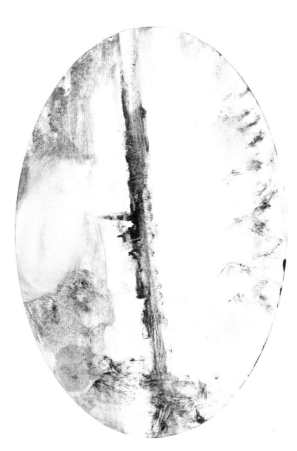

VENICE NO 132

VENICE NO 153

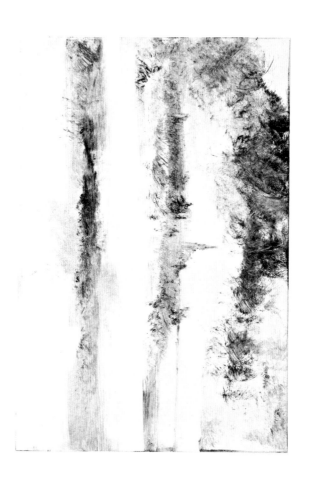

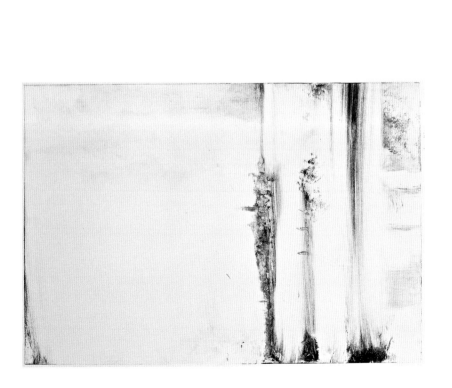

VENICE NO 170

VENICE NO 157

VENICE NO 212

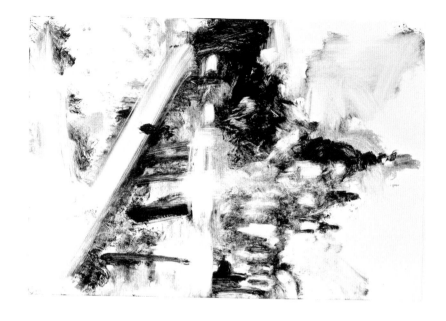

VENICE NO 214

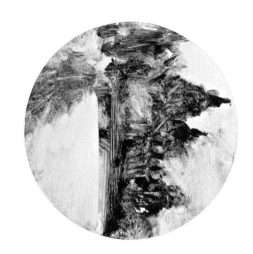

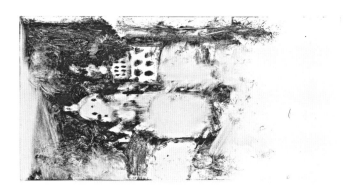

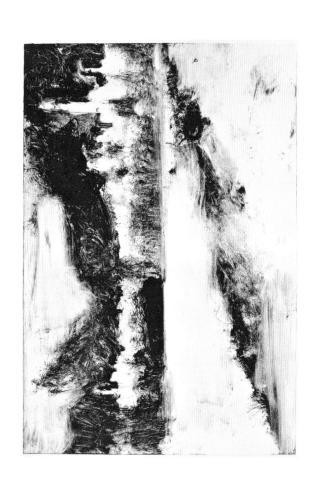

VENICE NO 251

VENICE NO 249

VENICE NO 253

VENICE NO 255

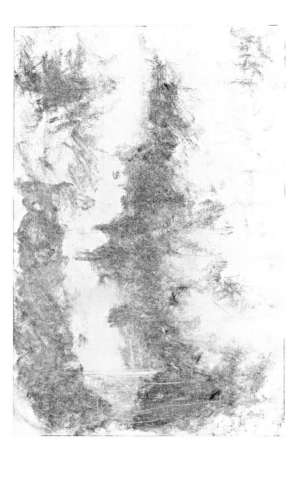

VENICE NO 262

VENICE NO 256

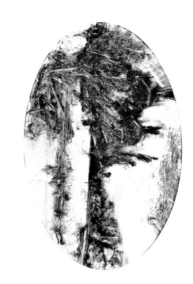

VENICE NO 271

VENICE NO 274

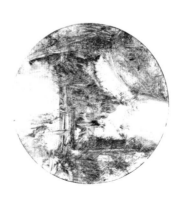

JOHN VIRTUE BIOGRAPHY

1947 Born in Accrington, Lancashire
1965–9 Slade School of Fine Art, London
1971 Moved to Green Haworth, Lancashire
1988 Moved to South Tawton, Devon
1997 Moved to Exeter, Devon
2004 Moved to London
2007 Moved to Italy

SOLO EXHIBITIONS

1985 John Virtue, Lisson Gallery, London
1986 Works: 1985–86, Lisson Gallery, London
1988 Green Haworth 10 Years: 1978–88, Lisson Gallery, London (travelled to Cornerhouse, Manchester and L.A. Louver, Venice, California)
1989 10 New Works, Lisson Gallery, London, (travelled to Louver Gallery, New York)
1990 Large Works and Miniatures 1989–90, L.A. Louver Gallery, Venice, California
1991 John Virtue, Serpentine Gallery, London
 John Virtue, Gallery Kasahara, Osaka, Japan
1992 John Virtue, Louver Gallery, New York
1993 John Virtue, L.A. Louver Gallery, Venice, California
 The Landscapes 1991–1993, Bernard Jacobson Gallery, London
1994 Darklands, Terra Nera, Galerie Buchmann, Basel, Switzerland
1995 John Virtue: New Works, The Douglas Hyde Gallery, Dublin (travelled to Arnolfini, Bristol; Whitechapel Art Gallery, London)
1996 John Virtue: Etchings, Jason and Rhodes, London
1997 John Virtue, L.A. Louver Gallery, Venice, California
 John Virtue: New Paintings, Jason and Rhodes, London
1998 Exe Estuary Paintings 1997–98, Spacex Gallery, Exeter

1999 John Virtue, Michael Hue-Williams Fine Art, London
 John Virtue: Paintings Newlyn Art Gallery, Cornwall
2000 John Virtue: Exe Estuary Paintings 1997–2000, L.A. Louver Gallery, Venice, California
2000–1 John Virtue: New Paintings, Tate Gallery St. Ives, Cornwall
 John Virtue, Michael Hue-Williams Fine Art, London
 John Virtue, L.A. Louver Gallery, Venice, California
2002 Last Paintings of the Exe Estuary, L.A. Louver Gallery, Venice, California
2003 Last Paintings of the Exe Estuary, Annandale Galleries, Sydney
 John Virtue: London Paintings, The National Gallery, London
2005 John Virtue: London Drawings, Courtauld Galleries, London
 John Virtue: Small London Paintings, Annadale Galleries, Sydney
2006 John Virtue: London Works, Yale Centre for British Art, New Haven, Connecticut
 John Virtue: New Small London Paintings, Jonathan Edwards College, Yale University
2007 John Virtue: Major Paintings of London, Annadale Galleries, Sydney, Australia
 John Virtue: Last Paintings of London, The Gallery, University of Plymouth
2008 John Virtue: London and Venice New Monotypes, Marlborough Fine Art, London

CATALOGUE LIST

A monotype is a *unique print*. The image is created by applying ink to a printing plate, using brushes, rollers, fingers or other means. The image on the plate is then transferred to a sheet of paper using a press. Although a second impression can be taken, such subsequent printings will be different in character from the first, being lighter in tone or because the plate will have been re-worked.

LONDON

LONDON NO 127, 110.2 × 222.5 CM

LONDON NO 128, 110.2 × 222.5 CM

LONDON NO 9, 37.5 × 54 CM
(PLATE SIZE 18 × 33 CM)

LONDON NO 14, 88 × 98.5 CM

LONDON NO 20, 100 × 124.5 CM

LONDON NO 26, 100 × 89.5 CM

LONDON NO 29, 61 × 121 CM

LONDON NO 34, 60 × 118 CM

LONDON NO 40, 101.5 × 124 CM

LONDON NO 43, 103 × 124 CM

LONDON NO 47, 101.5 × 101.5 CM

LONDON NO 50, 101.5 × 101.5 CM

LONDON NO 57, 44.7 × 42.5 CM
(PLATE SIZE 20 × 20 CM)

LONDON NO 58, 52 × 50 CM
(PLATE SIZE 27.5 × 27.5 CM)

LONDON NO 59, 37.3 × 35.3 CM
(PLATE SIZE 12.5 × 12.5 CM)

LONDON NO 61, 44.9 × 43 CM
(PLATE SIZE 20 × 20 CM)

LONDON NO 66, 44.9 × 43 CM
(PLATE SIZE 20 × 20 CM)

LONDON NO 67, 52.2 × 50 CM
(PLATE SIZE 27.5 × 27.5 CM)

LONDON NO 76, 39.5 × 30 CM
(PLATE SIZE 15 × 7.5 CM)

LONDON NO 79, 34.7 × 32.5 CM
(PLATE SIZE 10 × 10 CM)

LONDON NO 83, 44.9 × 52.5 CM
(PLATE SIZE 20 × 30 CM)

LONDON NO 92, 37.2 × 35.2 CM
(PLATE SIZE 12.5 × 12.5 CM)

LONDON NO 93, 37.2 × 35.2 CM
(PLATE SIZE 12.5 × 12.5 CM)

LONDON NO 97, 47.5 × 136 CM
(PLATE SIZE 30.4 × 121.5 CM)

LONDON NO 109, 121.5 × 60 CM

LONDON NO 111, 121.5 × 60 CM

VENICE

VENICE NO 291, 110.2 × 222.5 CM

VENICE NO 290, 110.2 × 222.5 CM

VENICE NO 2, 52 × 60.5 CM
(PLATE SIZE 27.5 × 27.5 CM)

VENICE NO 4, 52 × 60.5 CM
(PLATE SIZE 27.5 × 28 CM)

VENICE NO 17, 54.5 × 70 CM
(PLATE SIZE 37 × 54.5 CM)

VENICE NO 24, 54.5 × 70 CM
(PLATE SIZE 37 × 54.5 CM)

VENICE NO 25, 54.5 × 70 CM
(PLATE SIZE 37 × 54.5 CM)

VENICE NO 31, 37 × 35 CM
(PLATE SIZE 12.5 × 12.5 CM)

VENICE NO 32, 34.2 × 32.5 CM
(PLATE SIZE 10 × 10 CM)

VENICE NO 33, 31.5 × 38 CM
(PLATE SIZE 7.5 × 15 CM)

VENICE NO 38, 49.5 × 35 CM
(PLATE SIZE 25.2 × 12.5 CM)

VENICE NO 54, 54.5 × 70 CM
(PLATE SIZE 37 × 54.5 CM)

VENICE NO 55, 54.5 × 70 CM
(PLATE SIZE 37 × 54.5 CM)

VENICE NO 70, 54.5 × 70 CM
(PLATE SIZE 37 × 54.5 CM)

VENICE NO 75, 54.5 × 70 CM
(PLATE SIZE 37 × 54.5 CM)

VENICE NO 77, 47.5 × 70 CM
(PLATE SIZE 23.5 × 47.5 CM)

VENICE NO 78, 47.5 × 70 CM
(PLATE SIZE 23.5 × 47.5 CM)

VENICE NO 82, 54.5 × 70 CM
(PLATE SIZE 37 × 54.5 CM)

VENICE NO 85, 54.5 × 70 CM
(PLATE SIZE 37 × 54.5 CM)

VENICE NO 87, 47.5 × 70.5 CM
(PLATE SIZE 24 × 47.5 CM)

VENICE NO 90, 47.5 × 70.5 CM
(PLATE SIZE 24 × 47.5 CM)

VENICE NO 99, 34.2 × 32.5 CM
(PLATE SIZE 10.3 × 10 CM)

VENICE NO 102, 44.5 × 32.5 CM
(PLATE SIZE 20.2 × 10 CM)

VENICE NO 103, 36.8 × 35 CM
(PLATE SIZE 12.5 × 12.5 CM)

VENICE NO 109, 52 × 50 CM
(PLATE SIZE 27.5 × 27.5 CM)

VENICE NO 114, 54.5 × 72.5 CM
(PLATE SIZE 37 × 54 CM)

VENICE NO 119, 44.5 × 32.5 CM
(PLATE SIZE 20.2 × 10 CM)

VENICE NO 125, 51.5 × 50 CM
(PLATE SIZE 27.5 × 27.5 CM)

VENICE NO 129, 54.4 × 70 CM
(PLATE SIZE 37.5 × 55 CM)

VENICE NO 132, 54.4 × 72.5 CM
(PLATE SIZE 37 × 54.5 CM)

VENICE NO 143, 54.5 × 70 CM
(PLATE SIZE 37 × 54.5 CM)

VENICE NO 153, 54.5 × 70 CM
(PLATE SIZE 37 × 54.5 CM)

VENICE NO 157, 72 × 52.7 CM
(PLATE SIZE 54.5 × 37.5 CM)

VENICE NO 170, 34 × 42.5 CM
(PLATE SIZE 10 × 20 CM)

VENICE NO 212, 72 × 53 CM
(PLATE SIZE 54 × 37.5 CM)

VENICE NO 214, 52.5 × 50 CM
(PLATE SIZE 27.5 × 27.5 CM)

VENICE NO 249, 54.5 × 70 CM
(PLATE SIZE 37 × 54.5 CM)

VENICE NO 251, 72 × 46 CM
(PLATE SIZE 47.5 × 23.5 CM)

VENICE NO 253, 47.5 × 73.5 CM
(PLATE SIZE 23.5 × 47.5 CM)

VENICE NO 255, 47.5 × 73.5 CM
(PLATE SIZE 23.5 × 47.5 CM)

VENICE NO 256, 47.5 × 73.5 CM
(PLATE SIZE 23.5 × 47.5 CM)

VENICE NO 262, 54.5 × 70.3 CM
(PLATE SIZE 37.5 × 55 CM)

VENICE NO 271, 44.5 × 43 CM
(PLATE SIZE 20 × 30 CM)

VENICE NO 274, 44.5 × 43 CM
(PLATE SIZE 20 × 20 CM)

Marlborough

LONDON

Marlborough Fine Art
(London) Ltd.
6 Albemarle Street
London W1S 4BY
Telephone +44(0)20-7629 5161
Telefax +44(0)20-7629 6338
mfa@marlboroughfineart.com
info@marlboroughgraphics.com
www.marlboroughfineart.com

NEW YORK

Marlborough Gallery Inc.
40 West 57th Street
New York, N.Y. 10019
Telephone +1-212-541 4900
Telefax +1-212-541 4948
mny@marlboroughgallery.com
www.marlboroughgallery.com

CHELSEA

Opening Spring 2007
Marlborough Chelsea
545 West 25th Street
New York, N.Y. 10011
Telephone +1-212-541 4900
Telefax +1-212-541 4948
chelsea@marlboroughgallery.com

MONTE CARLO

Marlborough Monaco
Quai Antoine 1er
MC 98000
Monaco
Telephone +377-9770 2550
Telefax +377-9770 2559
www.marlborough-monaco.com
aet@marlborough-monaco.com

MADRID

Galería Marlborough SA
Orfila 5
28010 Madrid
Telephone +34-91-319 1414
Telefax +34-91-308 4345
info@galeriamarlborough.com
www.galeriamarlborough.com

SANTIAGO

Galería A.M.S. Marlborough
Nueva Costanera 3723
Santiago, Chile
Telephone +56-2-228 8696
Telefax +56-2-207 4071
amsmarlborough@entelchile.net
www.galeriaanamariastagno.cl

BARCELONA

Marlborough Barcelona
Valencia 284, local 1, 2 A
08007 Barcelona
Telephone +34-93-467 4454
Telefax +34-93-467 4451
infobarcelona@galeriamarlborough.com

LONDON *Agents for*

Frank Auerbach
Matthew Carr
Stephen Conroy
Christopher Couch
John Davies
David Dawson
Daniel Enkaoua
Karl Gerstner
Francis Giacobetti
Catherine Goodman
Daniela Gullotta
Dieter Hacker
Maggi Hambling
Clive Head
Charlotte Hodes
Paul Hodgson
John Hubbard
Bill Jacklin
Raymond Mason
Thérèse Oulton
Celia Paul
Cathie Pilkington
Paula Rego
Vladimir Velickovic
John Virtue
The Estate of Steven Campbell
The Estate of Chen Yifei
The Estate of Ken Kiff
The Estate of Oskar Kokoschka
The Estate of Victor Pasmore
The Estate of Sarah Raphael
The Estate of Graham Sutherland
The Estate of Euan Uglow
The Estate of Victor Willing

Important works available by
Impressionists and Post-Impressionists
Twentieth Century European Masters
German Expressionists
Post War American Artists

Modern Masters Prints,
Contemporary Publications and
Photographs available from
Marlborough Graphics,
London and New York

MONTE CARLO *Agents for*

Roberto Barni
Davide Benati
The Estate of Alberto Magnelli

NEW YORK *Agents for*

Magdalena Abakanowicz
Michael Anderson
Avigdor Arikha
L.C. Armstrong
Chakaia Booker
Fernando Botero
Claudio Bravo
Grisha Bruskin
Steven Charles
Dale Chihuly
Chu The-Chun
Vincent Desiderio
Thierry W Despont
Jane Dickson
Richard Estes
Red Grooms
Don Gummer
Israel Hershberg
R.B. Kitaj
Julio Larraz
Ricardo Maffei
Michele Oka Doner
Dennis Oppenheim
Tom Otterness
Beverly Pepper
Arnaldo Pomodoro
Will Ryman
Tomás Sánchez
Hunt Slonem
Clive Smith
Kenneth Snelson
T'ang Haywen
Stephen Talasnik
Tie Ying
Manolo Valdés
Viswanadhan
Wang Keping
Zao Wou-Ki
The Estate of Jacques Lipchitz
The Estate of Larry Rivers

MADRID *Agents for*

Juan José Aquerreta
Martín Chirino
Rafael Cidoncha
Alberto Corazón
Juan Correa
Alejandro Corujeira
Carlos Franco
Manuel Franquelo
Juan Genovés
Luis Gordillo
Kcho
Abraham Lacalle
Francisco Leiro
Antonio López García
Blanca Muñoz
Juan Navarro Baldeweg
Pelayo Ortega
Daniel Quintero
Joaquín Ramo
David Rodríguez Caballero
Sergio Sanz
Manolo Valdés
The Estate of Lucio Muñoz

Text © 2008 Paul Moorhouse
Photography Tino Tedaldi, London
Mike Taylor, London
Catalogue designed by Peter B. Willberg
Catalogue number 581
ISBN 13-978-1-904372-63-9
© 2008 Marlborough
Printed in Italy